Calligraphic STYLES

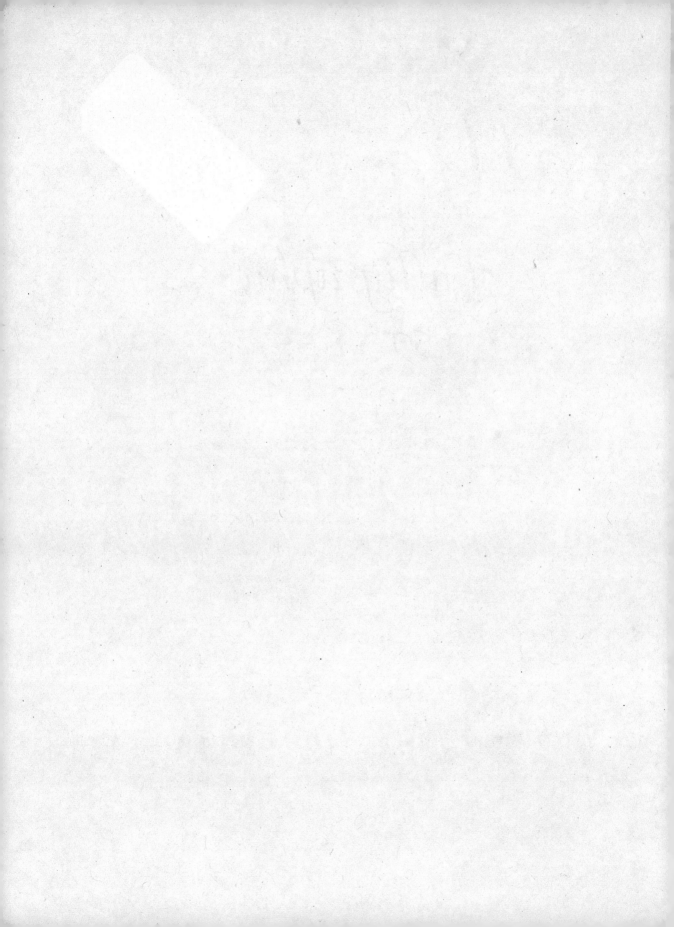

Calligraphic STYLES

Tom Gourdie

A Pentalic Book
Taplinger Publishing Company
New York

First published in the United States in 1979 by
Taplinger Publishing Company
New York.

First published in the U.K. by
Studio Vista, a division of Cassell Ltd.

Printed in Great Britain

Library of Congress Catalog Card Number: 79-52316
ISBN 0-8008-1181-X

Contents Page

Xyz ... ABCDEFGHIJKLMNOPQRSTUVWXYZ

ä
bcdefg
hijklmno
pqrstuvw
·xyz·

0123456789

calligraphy
is beautiful!

Tom Gourdie

CALLIGRAPHY,
and the historic
ALPHABETS

associated with it, are flourishing as never before
with calligraphy groups mushrooming, notably
in America. Beginners need detailed instruct-
ion if letters are to be properly formed, but if
professional instruction is not available, then
it is obvious that a book must suffice. This is
an attempt to meet such a need.
The historic alphabets are now being used most
imaginatively, as can be seen in the examples
which conclude the book, but there is also a growing
awareness of the value of simple, basic alphabets
which are more in keeping with our own times.
Beginning then with the basic alphabets, the prac-
tice in mastering them will undoubtedly prepare
one for the more demanding pen-manipulation
required for the various historic alphabets. Dexterity
is, of course, essential in this craft but pen-tech-
nique must not become an obsession, especially
with the up-and-coming calligraphers. Go through
this book slowly – therein lies success.

1

THE PEN

The broad nib is the ideal lettering tool as it provides contrast of stroke. As an introduction to the broad nib two pencils, bound together with a rubber band, may be used. This twin-pointed tool enables one to get the edge of the pen flat on to the paper, and, with the following exercises, shows if the pen is being held properly or not. Let the hand rest on its side and hold the pen between the thumb & fore-finger with the middle finger acting as a support, then let the whole hand move the pen, the movement coming from the wrist. The first exercise involves pointing the pen to the writing line at an angle of 45° and making up-strokes at 45°, then down-strokes at the same angle. This produces the thinnest & the thickest strokes. Now make horizontal & vertical strokes – they are equally wide. Circles are made in two movements – the left side first. This produces strokes going gradually from thin to thick and back again to thin.

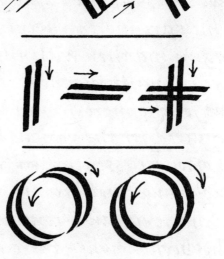

pattern-making as an introduction

to the lettering pen is essential if one is to acquire sufficient skill with this tool to produce reasonably well-formed letters.

Begin with this exercise which will help you to hold the pen at an angle of 45° to the writing line:

X X X X X X

The upstroke is the thinnest possible stroke and the down-stroke the thickest.

+ + + + + + +

This exercise shows horizontal and vertical strokes equal in width.

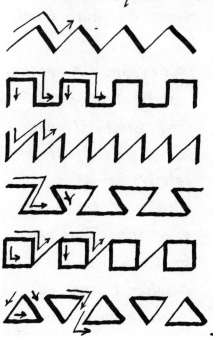

In each of the exercises of this group only pulled strokes of the pen have been used and pushed strokes avoided. The up-strokes at 45° are called sidled strokes and although technically they are more 'pushed' than 'pulled' (since they are drawn against the surface of the paper) they are allowed in formal calligraphy.

Border designs based on circular lines

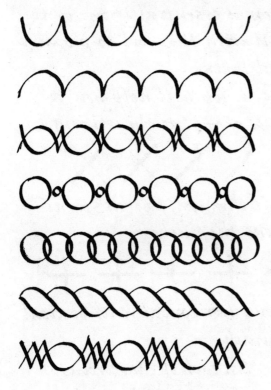

In the first & second of the designs shown here the pen is freely used, the patterns being made without lifting it off the paper. The third design is made by super-imposing 1 on 2. In doing 4, two strokes should be used for each circle. 7 is a combination of curved & straight lines.

Vertical stripe pattern exercises.

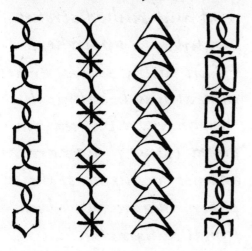

A great variety of stripe designs are possible with an edged pen. If two colours are used, a much greater variety is possible. This pen drill is an ideal introduction to lettering with the broad pen.

All-over patterns. From Stripe & Border patterns progression may be made to All-over patterns, using squared paper.

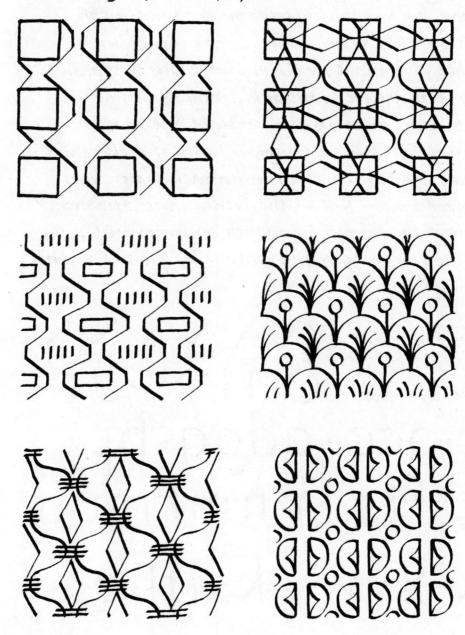

A simple alphabet or a 'basic Round Hand' alphabet.

Having acquired some skill with the edged or broad pen in making patterns, the making of letters will be much easier. Letters can be most subtle in form but for the beginner this very basic alphabet will be found sufficiently challenging. It is based on circles and straight lines and is derived from the Carolingian hand of a thousand years ago. The Carolingian hand has now been revived twice — first in the Renaissance Humanist style of the fifteenth, sixteenth centuries and then at the beginning of this century by the calligrapher, Edward Johnston.

The Pen Angle : ∧∧∧∧∧∧

The Elements : O ⌐ L X ⁼ JI

o: oce · adgq · bp

rj: fjs ⌐: nmrh · ι· u

x: xvwy · k · itl · z

The alphabet analysed

Holding the pen at an angle of 45°, do stroke 1 and then add stroke 2. The pen need not be lifted for the vertical stroke 3.

The letter b is almost a inverted, but for the ascender, which is almost twice the body (or x) height.

In this alphabet, when using the broad pen every stroke is pulled, hence the reason for making such a simple letter in two strokes. In making the second stroke flatten it out, like this ⌐, not like this ⌒.

Render d similarly to a, and make the ascender almost twice x height.

e may be rendered in two or three strokes. In the two-stroke version the cross bar is carried down to the left without lifting the pen ℓ. As a three-stroke letter the pen is lifted after 2 and the bar made from left to right, as a diagonal.

f is an ascender letter. Think of a as fitting into the top part. Note how far the cross-stroke projects to the right.

g has the body of **a** but with a descender which repeats the body height. It is a three-stroke letter if one does not lift the pen before adding the descender. Think of the body of **b** as fitting into the descender.

h is a two-stroke letter. All the arches in this alphabet are circular, therefore, do not start the second stroke too low and thus give an 'Italic' look to the letter.

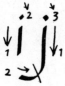

i and j are so simple as to require little or no analysis. Always remember the dots!

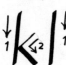

k and l are also simple. Add the chevron of k in one continuous stroke, but do not exaggerate it (<) — k should be the same as h in width.

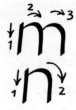

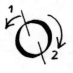

Letters of the alphabet frequently come in pairs. m and n are an obvious example. Remember always to make the arches rounded.

O is, of course, a completely circular letter. It is the key letter to the alphabet just as the oval O is the key letter of the Italic alphabet.

P and Q are another pair of similar letters, although opposites in construction. P is a three-stroke letter but Q may be made in two strokes. Note the flattening of the circular strokes* as they connect with the verticals.

R is a simple two-stroke letter. Take care to flatten off the top stroke just as we did with C.

S is a letter requiring considerable care and practice. It is based on two circles, one above the other, the upper being slightly smaller. It may be rendered variously, with the centre stroke first, then the base one and finally the top stroke or one may start with the top stroke, followed by the centre one and then the base. Flatten off the ends of the letter and so avoid making it look like a hook.

T is another simple letter, unique in that it is only 3/4 ths as tall as the other ascender letters. The cross-stroke may begin slightly to the left of the down-stroke with the major part on the right. One cross-stroke serves double t.

9

U U is simply n inverted. Take care to flatten off the end of the first stroke – this makes for a much more pleasing letter.

V V is obviously only one of a family of diagonally based letters. The thin strokes are half the width of the thick strokes – or should be if the pen is being held properly!

W

&

x y z

abcde

fghijk

abcdefghijklm

nopqrstuvwxyz

This simple alphabet is derived from the Carolingian alphabet of a thousand years ago. This is, indeed, the Carolingian alphabet in its simplest possible form.

lmnop

qrstu

vwxyz

The Capital Alphabet in its basic form will be used with the simple 'small-letter' alphabet and also with the Italic alphabet. The proportions of the classical Roman Capital (the Trajan Roman) have been closely observed in the design of this alphabet.

A B C D E F G H I J

K L M N O P Q R S

T U V W X Y & Z

Main Elements :

I — : E F H I L T

I V : A K M N V W X Y Z

D : D B P R

O : O Q, C G : S is made up of two circles, one on top of the other, like this 8 S.

L J : J U

The Proportions of the Capital Alphabet.

☐ square : M, OQ

☐ 3/4 squ. : AHNTUYV

☐ ½ squ. : BEFJKLPRS

◖ 3/4 squ. : CGD

5/8 squ : XZ

The alphabet analysed :

$_1$A$^2$: A medium width letter (3/4 square). Place
\to_3 the cross bar so that the areas above and
below it appear equal — not A nor A.

$_1$B$^2$: The upper loop is slightly smaller than the
$_3$ lower one. When a centre line is drawn the
upper loop should rest on it. This also applies
to the centre stroke of E and the cross-stroke
of H. Note also K·X·Y.

$_1$C$^2$: This letter is not exactly circular but follows
the Trajan Roman in being slightly

12

compressed so that the letter slightly over-laps the top and bottom lines between which the alphabet is drawn. The extremities of the letter are also straightened out so that it does not look like a circle with a bit cut away.

D Like C, D is mostly circular, therefore it should go above & below the lines. This means that strokes will not meet the down-stroke exactly at right angles : (⌐rise ⌊fall). This avoids a mechanically drawn look to the letter.

E F The arms of this letter are all the same length. Let the middle stroke rest on the line dividing the letter. The lower stroke of F is a trifle lower.

G The same applies to G as to C. The vertic-al stroke barely comes up to the centre line.

H I J The cross-stroke of H rests on top of the centre line. I is, of course, just a single stroke. The second stroke of J is straight-ened out to give the letter a better appearance.

K The angle of the two arms meeting (⟨)
is almost a right angle. Let them meet
slightly above the centre of the down·
stroke – where the centre stroke of E begins.

L As with E so with L – the horizontal
stroke is half the length of the vertical.

M The legs of M are slightly splayed and
the V part comes below the centre line —
but not right to the base. The letter is
a square wide.

N It is seldom that one needs to alter the pen·
angle from ↖ to ↖ but it is necessary
to do so when doing the down-strokes (1 & 3)
in order to make them more slender & more
contrasted to the diagonal.

Q It has already been suggested that the
round letters be laterally compressed, to
make them more subtle in appearance·
The tail of Q may have a slight turn
at the end. Q may be written as a two·
stroke letter or as a three-stroke, with a
pen·lift before adding the tail.

P Like D, the loop of P begins with a slight rise. The loop finishes just below the centre line. R is similar to P, but of course has that extra stroke which may be rendered as (1) or, much more gracefully, as (2).

R (1) (2)

S As with 'small' S, the capital form is a difficult letter to render well. The top circle (imagine two circles, one above the other) should be slightly smaller than the lower and the letter should have a slight forward slope as a result (see dotted lines). Also straighten out the ends, to avoid making S looking like a butcher's hook.

T T is a medium-width letter (like H) & of course is rendered in two strokes.

U Another 'medium' letter. Straighten out stroke 1 before it meets the down-stroke.

V V is simply an inverted A, but, of course, without the cross-stroke.

W Two V's together produce W but they are slightly compressed to make W less wide.

↓1 X ↓2 The letter is formed by crossing two strokes just above the centre line.

↓1 Y ↓2 The V part of Y rests on the centre line — Y & X are slightly less than medium width.

Z ↓1 →2 Z should observe the same slight forward tilt as S. It is a two-stroke letter.

Both alphabets together

When the alphabets are brought together make the capitals 3/4 of the height of the 'small letter' ascenders: A b C d F F

AaBbCcDdEeFfGg

HhIiJjKkLlMmNn

OoPpQqRrSsTt

UuVvWwXxYy

and Zz

A basic Italic alphabet is built on the oval – the round hand, however, was based on the circle. One naturally springs from the other for if one speeds up the round hand (as was done a thousand years ago to the precursor of our round hand – the Carolingian hand) the Italic characteristics (compression, slope & economy of stroke) begin to emerge.

The Elements: n u b a o x

n : n m r , h k

u : u y , v w v w

b : b p a : a d g q

o : o e c af , $_b$j , a_bs

x : x z y i t l

The alphabet analysed. The Italic alphabet is largely the result of writing freely & informally, so that a natural slope to the right is developed & letters assume an oval rather than a circular form. This also comes from the way the writing tool is held and manipulated, for, held properly (between the thumb and fore-finger & supported by the middle finger) and moved properly (by the whole hand in a nodding up and down movement from the wrist) the following writing patterns naturally emerge:

mm uu mm uu

Practise these before attempting the alphabet and letter forms will be more easily acquired!

a is rendered in two strokes. The turn at the base is quite sharp. Make sure that you produce this wedge-shape between the up-stroke and the down & try to make the letter slope to the same degree as this

sharp turn here.

b is simply the a movement inverted with the addition of the ascender, but the turn at the top* is rounder. Observe the wedge shape!

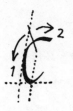 C is based on the oval O but note that the top is straightened out. Always try to incline the letter by balancing it as indicated. Keep the back fairly straight.

d is simply a with an ascender which may be twice X height or slightly less, as here. It is a three-stroke letter.

e is a two-stroke letter beginning like C, and then the loop is added. Let the loop join the down-stroke about halfway. It should be inclined exactly as C.

f is a three-stroke letter. Note how a fits into the top and how we have given the cross-stroke a slightly inclined angle. A descender may be added – if so, make it like this: f.

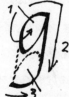 g is based on a. Render the descender so that b fits snugly into it.

h is just n with an ascender. Let the up-stroke swing up and away from the base – but do not exaggerate the wedge!*

i and *j* are the simplest of letters and if joined would be almost *h* inverted. The descender of *j* is similar to those of *g* and *y* — *b* fits into it.

k is similar to *h* except ofcourse for the way the loop is indented. If the body of *k* is placed in a parallelogram the loop will meet the diagonals where they cross and then descend the diagonal. *l* is a simple ascender stroke.

m and *n* are key letters since they incorporate the basic clockwise pattern. If anything make *m* slightly less wide than two normal *n*'s together. Do not make the turns too sharp at the top.*

o is another very basic letter – in fact this is what gives the Italic alphabet its character – its oval form ! It should be inclined at the same angle as the rest of the alphabet.

p and *q* are almost 'mirror' opposites ! Turn the loop of *q* quite sharply (1) but round the top of *p* rather more (2).

20

r is a single-stroke letter with an arm at the top of the up-stroke. Do not swing the up-stroke as much as that of, say, **n** — **r** not **r**.

S is inclined at the same angle as the other letters. It is made up of two circles, one on top of the other, the lower being slightly larger.

t is a ¾ sized ascender letter with a cross-stroke level with the top of **a**. Note its length.*

U is a single-stroke letter - like **n** inverted. **V** and **W** may be pointed at the base or slightly rounded. Note how **V** and **W** finish with a 'swing-in' to the up-strokes, and how the second down-stroke of **W** is almost backhand in direction.

X and **Z** are inclined similar to the rest of the alphabet and have the same proportion as **n**.

Y may be rendered with a **U** or a **V** body. With a **U** body it is nearer to a cursive form.

practising your lettering

The height of letters and the pen :

For most purposes the proportion of pen-width to 'x' height (the body height of the small-letter alphabet) should be 1:5, but where a heavier or lighter weight* is required this proportion will be altered. In the example above a is five pen-widths high, b (and all other ascender letters) is nine, g is ten and the capitals seven.

Spacing the letters should be quite simple
if one allows the eye to judge the area between letters so that it appears equal.

1 spacing letters

Leave a gap between descenders & ascenders.

2 spacing letters

In 1 the letters are strung out at an equal distance from each other. In 2 an attempt has been made to equate the AREA between letters. Spacing words (with a letter*) and lines are also important.

22

Towards a modern 'Round' hand

This heading is based on the lettering of a 10th century manuscript written in England. It shows the basic round hand alphabet now given serifs and finishing strokes. This creates more subtle pen techniques, which, however, are not difficult to acquire if the hand is allowed to move naturally, for all the forms are based on the circle.

abcdefghi jklmnopqr stuvwxyz

Notes on the alphabet

1 The down-stroke is sloped like the capital A. From the construction it is easy to see how the small-letter came to be derived from the capital A A A a

The serif is made as illustrated – it is really a small thickness or wedge at the top of the ascender.

d is rendered similarly to d in the basic alphabet with the addition of the serif and the slight turn of the pen at the foot of the downstroke.

e is characterized with the compressed loop and the projection of the diagonal stroke.

f is both ascender & descender and the cross-stroke is in line with the top of a. The cross-stroke slides down, then out to the left before it crosses over to the right.

g is a beautiful letter if done with some swagger – but if you are an absolute beginner it will require much practice. The bottom is almost an oval lying on its side whereas the top is circular.

h looks as if it were intended to form b with the turn in of the second down-stroke – this persisted even to the 15th cent. Italic.

i j i and j are simple letters. Finish j by turning the pen so that the right hand edge only is in contact with the paper.

k Render the second stroke of k as a single stroke with a swing in to the down-stroke and then a swing away & down for the finish of the letter.

l l, like i, finishes with a rounded stroke into which one may imagine a circle fitting.

m n In this alphabet m is required to be render-ed in three strokes and n in two, but in examples of 10th century Carolingian writing such was the urgency of the writer that those letters were often written cursively — i.e, without pen lifts.

p q P and q are almost exact opposites or mirror images of each other. Note how the curved strokes straighten out before link-ing up with the down-strokes.

r The arm stroke of r is rendered with a little flourish.

25

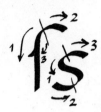

Here are two forms of S, the first being the 10th century way of writing this letter but now quite obsolete. It is like f but without the cross-stroke.

T begins with a horizontal stroke (at x height) and then the lower, circular part is added. It is like C with a flat cap.

U may have the wedge serifs (the earlier form) or may be written in the second way which is quicker and economical of stroke. This is the usual trend in lettering.

V in this form was not included in the Carolingian alphabet. To produce the thin down-stroke the pen angle has to be gradually altered (see arrows). This also applies to the second example of W.

The thin down-stroke of X has been prolonged and brought below the base line ~ a 10th century practice.

Y is simply l and j joined together.

Z, like W, may have the down-stroke altered in width as it descends.

26

CAPITALS

to match the preceding small-letter or miniscule alphabet. There should always be a family likeness between small-letters and the attendant capitals, so wedge effects have been given to the capitals of the Basic alphabet to match. The emphasis is on the top of the strokes so the bottom of the strokes remains unaltered.

ABCDEFGHIJ
KLMNOPQRS
TUVWXY&Z

As can be readily seen the addition of the wedge has altered the look of the Basic capital alphabet.
Letters not altered are A M O Q.
The wedge effect is added to the left side of the down-stroke I H I J K . The exceptions are V and W.
Take care not to make the wedge too prominent. It must be a discreet addition H not H

The Foundational Hand as devised
by Edward Johnston.
The rediscovery of the broad pen as the lettering tool
of the ancient scribes and his study of Carolingian
manuscripts gave the doyen of British calligraphers,
Edward Johnston, to realise his most beautiful and
practical Round Hand alphabet. He called it the

Foundational Hand

Here are the alphabets

abcdefghijkl
mnopqrstu
serifs: ℸ · vwxy&z · ⌐ feet:

ABCDEFGHIJK
MNOPQRSTU
VWXYZ

a *or* **a** : a may be rendered as a two-stroke or three-stroke letter. All rounded parts should be circular.

b If we count the serif stroke, then b is a three-stroke letter but usually the serif stroke is not counted.

c C, like the basic example, has the second stroke straightened slightly. The little 'tail'* is made by turning the pen on to its left edge and drawing it downwards.

d d is a three-stroke letter formed from the union of C and l.

e e is another three-stroke letter and in this alphabet the crossbar is diagonal.

f f is a three-stroke letter, poised, in this alphabet, on its foot. To make the foot let the pen go down & out to the left and then sharply (at a slight angle downwards) to the right. Notice how it seems to be balanced on tip-toe. The cross-stroke begins with the pen placed above the cross and then swung down to the left and then across.

g This letter is a challenge to one's skill as a penman. This is an occasion when one might trace with advantage in order to acquire the swing to the lower part.

h h is a two-stroke letter, the first one ending with a slight turn to the right, while the second stroke has the rounded exit common to all letters ending like *a*.

i j Always finish i with a substantial turn to the right and in finishing j turn the pen gradually on to its edge to end up with a hair-line.

k Try to do the second stroke with some hint of a flourish! Tracing will help here.

l m n l is a simple down-stroke turned at the base as fully as i. Both m & n are of course basic clockwise letters—make sure the arches are round!

p q p & q are rendered exactly as the basic forms but with the addition of an entry stroke to p and 'feet' to both letters.

 Give r a rounded arch as an entry stroke
and add the arm with a slight wave effect.

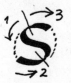 S in this alphabet fits into a circle — the
centre stroke should be done first, then
the bottom one and, finally, the top.

Begin with a sidled up-stroke and then
do the vertical stroke, with a rounded
exit. Add the cross-stroke, attaching it
to the sidled stroke. Note its length.

U is almost an inverted n but for the
serif given to the second stroke.

The pen angle is altered gradually as
the second stroke is made - see arrows.

The pen angle alters here, too, until the
strokes are almost hair-lines.

Make x fit into a square. Note the top &
bottom of the second stroke.

Like 8, y is a subtle letter, with slight
change of angle to the second down-stroke
Try tracing it, if in difficulty.

This is another letter, apparently simple
but subtle to do. Tilt the horizontals slightly.

pen angle
changes.

 A is a three-stroke letter. The second down-stroke is swung to the left as it descends, being curved (see illustration) rather than absolutely straight. The foot is done as shown – practise this !

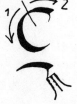 B is a two-stroke letter. The swing from the down-stroke to the slightly tilted horizontal will require practice — tracing will help.

C is a two-stroke letter. Once again straighten off the upper stroke and try the flick finish by turning the pen on to the left edge and drawing it down towards you.

Do D as you did B. Prevent a mechanical look to the letter by a swing up and round to the second part of the letter.*

E and F differ only in the bottom cross-stroke which, because it is lacking in F, causes its centre stroke to be slightly dropped.

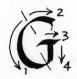 G is just C with the addition of the short vertical capped with a finishing horizontal.

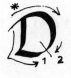

H H is simply two vertical strokes joined by a horizontal which should rest on the centre line.

l J L and J need no further explanation but to finish J with a hair-line by turning the pen on to its edge.

KL Note the swing down and in to the vertical stroke by the second stroke of K*. They meet on the centre line. Note the subtle tilt of the base of L*.

M Let the 'legs' of M be slightly tilted and take the V part almost to the base – this example is a fraction off it *.

N Tilt the pen to about this angle → for the down-strokes 2 and 3.

Q O and Q need no explanation — but to remind you to make them slightly less than a circle wide.

PR P and R are another pair of 'similar' letters. Do not be afraid to swing R !

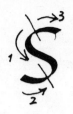

S is not easy to do well. Care must be taken to balance it properly, to straighten off both ends and to get a beautiful swing to the centre. Trace this!

Tilt the top stroke slightly down. Let the letter fit into 3/4 of a square.

U Note the angle at which the 1st stroke meets the 2nd. Finish off the 2nd stroke by bringing the pen momentarily to a halt then making a slight diagonal up-stroke - ℓ.

V requires the pen's angle to be altered for the second down-stroke to make the stroke gradually thinner. Note that **W** is just two V's but strokes 1 and 3 are not exactly parallel.

The 2nd down-stroke of **X** has the cap added as the final stroke.
 Y is a V top on a stem. As with V, the pen's angle is altered for the 'thin' down-stroke then is altered again for the stem. Let the base of **Z** be tilted down rather more than the top.

Italic alphabets, small-letter & capital

The natural progression from the Round Hand is to Italic. The essential characteristics of Italic script are :

1 Compression
2 Slight forward slope
3 Rhythm or movement.

While informal Italic requires very few pen·lifts (most letters are single·stroke) the formal version, due to being written with the broad pen, demands that the pen be lifted frequently.

e.g. 'a', as here, is a single·stroke letter since it is written with a fine nib, but

a, written with a broad nib is a 2·stroke letter. This is because the pen is pulled, never pushed, when writing as large.

abcdefghijklm
nopqqrstuvwx
yy and z

a is a two-stroke letter-\cup ι^2. Always turn sharply at the base and allow the movement of the hand (as it were nodding) to dictate the slope.

Use either top

b is a two-stroke letter. The 'counter' (the part enclosed) is an oval, here inverted.

As in the other alphabets straighten the second stroke of **C**.

d is simply **a** with an ascender, which may be extended if desired.

e is a two-stroke letter. The loop is brought into the centre of the down-stroke and, if desired, an up-stroke ⁄ is added.

f is an elegant letter but such a long down-stroke requires care to keep it straight. Imagine **a** fitting into the top and **b** into the bottom of the letter. The cross-stroke is placed through the centre.

g is 'a' with a descender which has a subtle swing and is attached to the body. Trace it!

h is a single-stroke letter. Turn the base of the second down-stroke sharply.

Turn **i** sharply at the base. Add the base stroke of **j** so that **b** can fit in. The dots may be made `•↘` or `↗`, as you wish.

l is simply a down-stroke, turned sharply at the base. **k** is also a graceful letter if the chevron `<` is allowed some freedom, as rendered here. Do not let the in-stroke come right in to the main stem.*

m & **n** are basic clockwise letters rendered without pen lifts.

O is the key letter to the Italic alphabet — it is a proper oval in shape, rendered here in two halves.

p & **q**, as noted in the other alphabets, are opposites. **p** is rendered in three strokes while **q** is a two-stroke letter.

Q, based on **O**, is also a two-stroke letter with the tail as an extension of the second one.

37

r *r* is another single-stroke letter. The arm has a slight wave. It is easier to control this part of the letter if one pauses briefly at the top of the stroke* before adding the arm.

S Think of **S** as fitting into an oval and it will come quite easily, but, if in difficulty, why not trace?

t Begin the letter with an entry stroke, taking the letter above the line ⊥⋯⋯. Add the cross-stroke from the 'entry' stroke. Finish it with a slight lift of the pen.

U V Here, U is exactly N inverted.

W V is a one-stroke letter with the down-stroke tilted very slightly to the left and the up-stroke swinging in to the left. The down-strokes of

X W are slightly splayed and the second one given a subtle swing. It finishes like V.

Y Y Note how the Italic X fits into A. There are two ways of doing Y, — with a V or a U body. In a purely cursive style

Z the pen need not be lifted except to add the base stroke Y Y. Note the tilt to Z.

abcdeffghijklmn

This is another version of Italic in

opqrstttuvwxyz

which the ascenders are given horizontal strokes
and *p* given a horizontal stroke to the descender.
Note double f and t: **ff, tt.**

The Capitals: The simpler form of Italic may
be matched with simple capitals.

aAbBcCd DeEfFgG

but the second version is matched with more
ornate ones, called *Swash Capitals:*

Do not try to draw these.

ABCD
EFGH
JJKLM
NOPQ

RSTUV
WXYZ
A & Z

Swash Capitals must
be **written** with the hand moving freely!

∫I-,A Let the hand rest on the paper—
then let it make a swinging
movement down and to the left for
A₁ stroke 1. Stroke 2 is almost vertical and
comes from bringing the pen down towards
A₂ the body. Then add the cross-stroke, not
too high①, not too low.②

B Do the down-stroke first then add the
rest of the letter. I have exaggerated the
lower part.

C Do C exactly as you do small-letter C,
straightening off the top stroke.

D D is rendered in the same way & sequence as
B, the circular part beginning to the left
of the down-stroke.

E E may start with the down-stroke or
with the top horizontal. It may be a
three or four-stroke letter. F is just E
without a third horizontal.

G G is a two-stroke letter. The vertical stroke
does not reach half way.

40

H is the first of four letters beginning alike so they must all conform. Here it is written as a three- stroke letter but it could have been five, had the pen been lifted at the starred points.

These are the other letters just referred to. Trace *K* to get the proper swing to the chevron part.

L demands more than usual care, especially to do it in a single stroke.

To get the proper splayed effect of this letter it might be worthwhile to trace. It can be a two or four-stroke letter.

N is a three-stroke letter, the troublesome stroke being the centre one with its subtly curving line ⟍. Trace it!

O is the key letter to this alphabet. Make sure it is a proper oval in shape.

P is similar in construction to *B*, *D* and *R* (but for the leg).

Add this tail to *O* and get *Q*. Note its curve.

R is just P with the down-stroke added and should be rendered freely. The first down-stroke of P and R may finish with a slight flick, see illustration.

Compression is the essence of Italic so S has to be designed to fit into an oval.

T begins with the cross-stroke which is given a swagger and tilted down a little. Finish the down-stroke with a little flick.

Begin U with the same introduction as H, I, J, K, and finish with a like stroke, as if to balance the letter.

V may be very soberly done with straight down-stroke (advisable for the beginner) or it may be given a slight swagger. Try to do both V & W in single movements, and treat W as V – either very soberly or with a controlled swagger. For X extend the right to left down-stroke above and below, if desired, and let the letter fit into small 'a'. Y may be in two forms – with a V or U top.

The alphabets already given

are the calligrapher's essential material but there are others which are useful and they are, therefore, included, not as historical curiosities but as worthy alternatives. In their order we shall examine

> Square Capitals,
> Rustic Capitals,
> Uncials,
> Half Uncials &
> the various Gothic alphabets.

SQUARE CAPITALS. The Roman Capital

is to be found everywhere today. It is the most enduring of alphabets and, for beauty of proportion & design, has never been equalled since devised two thousand years ago. It shows the influence of the pen in its contrast of stroke-width and it was in turn closely imitated by the scribes of the early christian era. This is the back ground to the Square Capital or as it is also known - the Quadrata.

ABCDEFGHIJKLMN
OPQRSTUVWXYZ

SQUARE CAPITALS

In this alphabet, also called Quadrata, the pen is used to capture or simulate the effect of the carved Roman capital. It demands considerable skill to manipulate the pen at varying angles.

Elements : Pen angle

Serifs : Top

Base

D- DBPR

X- VWA

I TZ ⊂ S

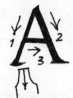

A is, of course, in three strokes, all varying in width. Point the pen at right angles to the writing line for the serifs.

B is a three-stroke letter. Note the slight rise to the upper loop & slight fall of the lower.

44

C As in the carved Roman C is not exactly circular but compressed. The lower part of the serif is added with a downward twist of the pen.

D, like B has a rise and fall at the beginning and end of the loop. In making the Square Capital, do the upper part of the loop first.

The arms of E & F are half the letter height. Let the lower arm of E be tilted down slightly, rising towards the end.

The same rules apply to G as to C. The vertical stroke comes up to the centre line.

As with E, the centre stroke of H lies on the centre line.

Let the chevron < part of K meet the vertical at the half-way point. Tilt the base of L.

. Do not over-splay the outer strokes of M. Note how far the V part comes down

The pen is held more horizontally for the vertical strokes of N.

OQ The pen angle is as usual 45°. Add the tail of Q at an approximate angle of 30°.

PR The loop of P may connect to the down-stroke or not, and this also applies to R.

S S is always in three strokes, the centre coming first but the others coming as you wish.

T The Trajan Roman T has a tilt to the cross-stroke, so we have the same here but balancing it with the serifs placed below & above - T

U The serifs at the top and bottom of the second stroke should be identically opposites.

V For the serifs of V and W keep the pen pointed at 90° to the writing line ↑. W

W may have a serif topping the centre of the letter & the final strokes of V and W may vary: ⟩ or ⟨

X X incorporates the strokes of V. Keep the pen almost at right angles to the writing line for the serifs. Do not exaggerate them.

Y Y incorporates V and, therefore, the same construction applies.

Z Tilt the base of Z so that, like E and L it is balanced at a point indicated here ⊿

RVSTIC CAPITALS

are the exact antithesis to the Square Capital – they are rendered freely, speedily and economically. The Square Capital is tedious to do & at a time when all writing was on skin, was far too wasteful of space so something more practical and economic was needed, hence the Rustic capital. It was useful for sgraffiti, too, as the walls of Pompeii can testify & for this the writing tool was a chisel-ended reed. It is a pure pen-inspired alphabet. To acquire the compressed effect the pen is held almost parallel to the writing line

pen angle

ABCDEF6CHIJKLM
NOPQRSTV or UVW
· RVSTIC · XYZ · CAPITALS A/Z

Elements

1: EFHIJKL · 2: BDPR · O: OC6Q
· S · V: VUVWXYZMN·A

ABCDEFGHIJ KLMNOPQR STUVWXYZ

UNCIALS and half-uncials ·

Calligraphy has never stagnated; it has always been a most lively art, and has always gone from one style to another — usually from one extreme to the other. This is most apparent in the historic alphabets which changed from rounded to compressed forms and back again almost with monotonous regularity. The Uncial then is in direct contrast to the Rustic Capital in two most important ways :

 ① It is round in character.

 ② The pen-angle is opposite : this ↑ as compared to this ←

The edged pen makes rounded strokes much more easily than straight, hence this alphabet is a true pen-made one, quite different in character from the Square capital.

48

THE UNCIAL
ANALYSED

Pen angle : The angle of the pen
to the writing line is
almost a right angle,
as illustrated.

The Elements : 1 ─ ○ / \

 A may be made in two ways. In either
way it is a two-stroke letter.

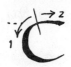 B may be made with or without the
ascender. It is a three-stroke letter.

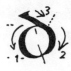 The roundness of the Uncial is emphasised
as in C ─ a two-stroke letter.

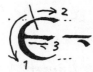 Make the circle first and then add the
ascender, as the easier way to make D.

E is just C with a centre stroke. Note
how to make the serif on this stroke!

F is a three-stroke letter whose top-stroke is curved, not straight. It may also be described as a descender letter.

G is a two-stroke letter with a descender stroke which is tilted to the right.

h is a simple two-stroke letter composed of simple straight & curved strokes. It is an ascender letter.

I and **J** are the simplest letters of the alphabet, and J is a descender letter. Bring the pen on to its edge for the turn at the base.

k like h is an ascender letter and is also written in two strokes.

L is also an ascender letter. Let the horizontal stroke tilt down very slightly.

M is a three-stroke letter. The centre stroke may be given a serif, if desired.

N is a three-stroke letter. The centre stroke may be rendered first or as the second stroke. Tilt the pen to make the down strokes lighter.

50

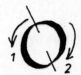 **O**, as in formal alphabets generally, is a two-stroke letter.

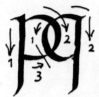 **P** and **q** are 'twin' letters, as it were, differing only in the number of strokes they both require – three for P, two for q.

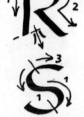 Always keep the pen pointed almost at a right angle to the writing line ↑. Do the second stroke with a certain swagger. **S**, because of the pen-angle, is difficult to do, especially the first stroke.

T is given here in two forms, the first of which was the more commonly used.

The curved character of **U**'s first stroke is the key to the special look of the Uncial.

These letters also are important for giving the Uncial its unique character.

The right-to-left down-stroke is taken below the line in **X**. One may also do **y** like this ⌐Y

Z does not change greatly.

The half-uncial alphabet

was the introduction to our two alphabet system, of Capitals (Majuscules) and small-letters (Miniscules)

abcdefghijk

This is a modern, modified form of half-uncial

lmn nopqrs

based on the one which the 6th to 8th century Irish

tuvwxy and z

scribes adopted and perfected. It is the hand used in the Book of Kells, the treasure of Trinity College Library which is thought to have been written at IONA. The text was obviously written fairly quickly,

the quick brown fox jumps over the lazy dog

which is not surprising considering the simple construction of this very practical alphabet.

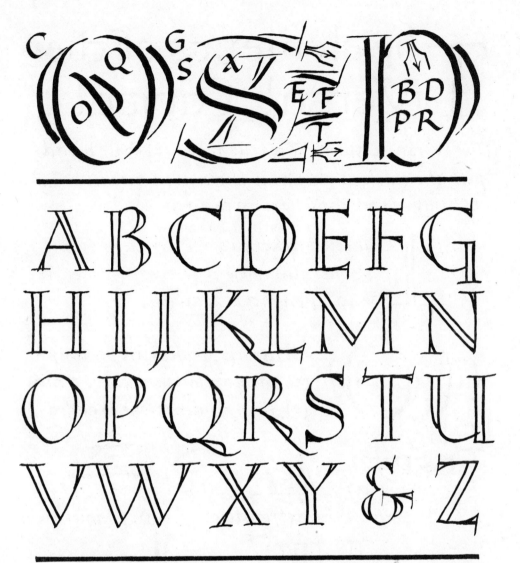

ABCDEFG
HIJKLMN
OPQRSTU
VWXY&Z

VERSAL

Capitals are a pen-built form of the 'Trajan Roman' and are normally used to begin verses and chapters but may also be used to make impressive panels of lettering. They began to be used in the ninth century and are just as useful for today.

The elements of the Versal Capital:

The Versal Capital is a true product of the broad pen, the thick strokes and the curved strokes being built up as in the following diagrams:

(1) : Thick strokes are rendered as two strokes narrowing towards the centre and opening out again.

: All curved strokes are built up
(a) with a flattened curve & then
(b), the rounder stroke, is added.

The Serifs:

(a) (b)

* Serifs at the extremities of thin (single) strokes

(c) (d)

Serifs at the top & bottom of **B. D. P & R**

* The serifs are built up with a short stroke swinging to or away from the down-stroke and then both are connected by a thin stroke made with the pen held vertically – see (a) & (b)

A is rendered by making the double-stroke first. The thin stroke is in line with the top of the outer stroke of (1) - see the dotted line. Note the angle of the pen for the serifs.

As usual make the upper loop slightly smaller. Note the detail showing how the curved strokes are attached.

Flatten the inside curve (1), then add the outer stroke. Alter the pen angle for the serif.

As with B, the same procedure is observed for the flattened curve and joining it to the vertical stroke.

Observe the sequence of strokes for the serifs, particularly of the centre strokes:

G is rendered exactly as C but with the addition of the down-strokes which may be treated as a descender (1) or as a short vertical (2), coming almost to half-way.

or

H J Both letters are simple. H may have
a small circle attached to the under-
side of the cross-bar as a decorative touch.

K L Note how the thick part of the tail of
K comes down just to the base line
This also applies to the tail of R.

M M may have the vertical strokes splayed
a little — but not overmuch. Let the V
part come down three quarters of the
N way. Note where the vertical strokes*
begin in both M and N in relation to the
top of the diagonal strokes.

O Q Remember to flatten the inside strokes
of both O and Q. The tail of Q is like
the tails of K and R.

P R The loop of P may be attached to the
down-stroke or left unattached, as here.
. Let both loops come below the centre-
line (dotted).

S This is perhaps the most difficult letter of
all. Note the tilt to the left side !

T — T may be rendered in those two
ways. Note the construction of the first
cross-stroke :

UVWXYZ

The remaining letters are mostly made up of diagonal strokes. Points to note are (1) The serif strokes of X are added to the inside of the 2nd down-stroke, (2) The base of Z has been given a slight tilt, and (3) Both V and W come a trifle below the base line and their diagonal strokes are very slightly curved.

ABCDEFG
HIJKLMNO
PQRSTUVW
XYZ

A very different alphabet, quite modern in appearance has been devised, simply by leaving out the final stroke to the serif. And many decorative effects may be given this alphabet, for example:

ABC

Gothic Script is composed mostly of

straight lines, with curves restricted to a few of the capital letters. It is, therefore, an angular script and when closely packed can be very difficult to read – especially if one is unaccustomed to it. It is not without its uses, however, and is, therefore, given here in the hope that all those whose interest in lettering is restricted to Old English will be reminded that the edged pen, and not the pointed, is the only true lettering tool with which to produce the thick strokes. A simple version is given first and other looser or freer and less compressed variations follow.

Pen Angle : The pen angle is no longer at about 45° to the writing line but rather steeper. The vertical strokes are heavier (or thicker) than those from left to right

Main Elements:

abcdefghijklmno

pqrstuvwxyz

The alphabet analysed. The pen-angle varies quite a lot throughout the alphabet — be mindful of this!

a Note the angle of the finishing stroke — all longer diagonal strokes are inclined slightly from the horizontal → but short terminal strokes are inclined steeply.

b The ascenders are short (and so are the descenders) so that lines of writing can be fairly close, to give a rather dense effect.

c d Note the steep inclination of the top stroke of c and the terminal stroke of **d** d — both point in the same direction The second stroke of the alternative d begins as a diagonal with the pen-angle at 45°

e f g There is a pen-angle change for the second stroke of e and for the cross-stroke of f. Note the turn to the base of g.

h i j Note the descender effect of the second stroke of h and how this stroke, like j, finishes with a slight turn to the left.

k l Note the changes of pen-angle in k – this demands considerable manipulation of the pen.

m n Begin the arch-strokes of both with a short up-stroke *n̆*.

o p q Note the curve to the final stroke of p.*

r s The second stroke of r drops steeply. Note the direction of the top & bottom strokes of S.

t u v w V is obtained by closing U *n̆*. Treat the arch-strokes of V and W similarly to those of M and N.

x y z Note the changes of pen-angle in X & the curved base stroke of Z.

ABCDEFGHIJKL

MNOPQRSTUV·

WXYZZ·Alpha!

The Gothic Alphabet need not be so stiff
but may be rendered more freely, with a marked
gain in rhythm. This will inevitably result from
repeated practice of the basic alphabet.

abcdefgh ij klmn

opqrstuvwxyz

ABCDEFGHIJ

KLMNOPQRS

TUVWXYZ

Before attempting these alphabets, study them care-
fully in order to grasp the main elements. Once this
has been done it should not be so difficult to produce
the letters without reference to the examples.

The Gothic Black Letter or Old English

as it is more commonly described, can become
quite complicated, especially with the introduction
of the vertical hair lines which were rendered

ABCDEFG
HIJKLMN
OPQRSTU
VWXYZ:BC

with the pen held pointed horizontally ←. Other
hair lines may be added to letters with large bowls
such as D, G, O, P and Q but it is better not to
over-do the decoration. If we examine the simple
basic capitals it will be seen that, shorn of the
decoration (blobs * and hairlines) and rendered
more severely, the above hardly differs from it.
+ B and C, left untouched, illustrate this very well.

abcdefghijklm
nopqrsſtuvy
x · and ʒ · wyx···

Rotunda or Round Gothic was
favoured in Southern Europe, notably in Spain,
Portugal and Italy, in preference to the pointed
Gothic of the North. It is a simple looking letter but
is far from being simple to do as the pen has to be held
pointed to the writing line at 30° or so ↑ and then,
for the letters n m h k f i pq, has to be pointed per-
pendicularly to the writing line to produce flat
bases _ n l _ to do so, it is gradually turned, &
pointed at this angle: ↑ L

A suggested Capital for Round Gothic:

ABCDEFGHIJK
LMNOPQRST
UVWXYZ

Humanist Writing

The formal book hand of the Italian Scribes of the 14th and 15th centuries.

Humanist Writing was quite a remarkably disciplined hand, as rigid as any Gothic and just as exacting. On occasion it was so disciplined and so regular that it might be taken for type — and, indeed, the first Roman type-faces were based on it just as Gutenberg based his Gothic on the hand-written script he knew so well. The following is a twentieth century version.

Pen Angle: ⊤ – flatter than the usual 45°.

Main Elements: C), ⌐⌐U, I I ⌐I

⌐, o l q Note the short ascenders & descenders

abcdefghijklmn
opqrstuvwxy&z
A:AbCdE:B Render the Capitals this height.

The Capital alphabet is just the pen-built form of the Roman, modified to match the small-letter alphabet.

Cursive Writing

is handwriting which 'flows', with
letters joined to one another with lines or strokes
called ligatures. It demands a rather different
approach to the subject — above all, in the way
the pen is held and manipulated.

The pen has to be held easily, between thumb &
fore-finger with the middle finger placed behind
it as a support. The disengaged fingers should be
turned in towards the palm but not entirely
closed — the side of the hand should be like a
question mark ?, if the proper pen hold has
been acquired.

The arms should hang easily & not be tucked into
the side of the body, nor spread out. With the hand
placed on to the paper the pen should point on
to the writing surface at about 45° and also be
held so that the shaft is pointed up the fore-arm
and off the shoulder.

The pen should be moved by the whole hand
moving in a nodding fashion from the wrist —
this is why we refer to handwriting and not to
it as finger-writing ! The paper should be placed
immediately in front of the writer on a slightly
sloping surface, and be tilted a little up to the right

for the right-handed and tilted down to the right rather more if you are left-handed.

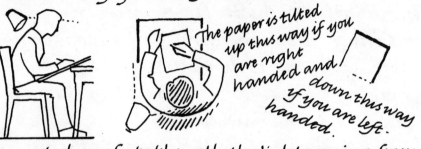

The paper is tilted up this way if you are right handed and down this way if you are left-handed.

Be seated comfortably with the light coming from the left or, if you are left-handed, coming from the right. Write, if possible, on a slightly sloping surface was perhaps unnecessary advice in the days of the writing desks but a drawing board resting on one's lap & supported by a table does very well for us now.

Pens and ink.

For the Italic style, in order to get the thicks and thins, edged pens, ranging from fine through medium to broad, are available as fountain pens. They are also provided with special left-oblique nibs for the left-handed. Black inks (permanent black) are now popular for use in fountain pens, and they are really black! Do not use waterproof black in your pen.

Paper:

Any good quality paper will do but a special calligraphic paper with a delightfully smooth surface is now available for correspondence and in sheets (on application) for larger work.

66

Italic Handwriting: The alphabets.

abcdefghijklmnopqr
rstuvwxyz

ABCDEFGHIJKLM
NOPQRSTUVWXYZ

The Basic Patterns

Handwriting, to be practical, must be capable
of being written at speed, yet remaining legible.
All the letters must therefore be derived from the
two basic patterns : MM UUU mn uu

mn : m n r h k b p
uuu : i t l, u v w y,
a d g q, o e c q,
f j s,
x z z.

Some of the letters
are shown as hav-
ing alternative
ascenders and
descenders. For
a practical style
they must be as
simple as possible.

A simple alphabet:

abcdefghijklmnopqr
stuvwxyz· ABCDEFG
HIJKLMNOPQRSTU
VWXYZ

Joining the letters: To be of any value
handwriting must flow from one letter to another
through joining strokes. Letters ending, therefore,
with an exit stroke (a c d e h ι etc) will join
easily to letters beginning with an entry stroke:

acdehiklmnuz join naturally to:
ijmnprstuvwxy : ai aj
am, an, ap, ar, as (note how s has been
changed) at, au, av, aw, ax, ay (az)

Letters from the first group join easily to the
 ascender letters :
 ab (a/b), ah, ak, al.
Letters with horizontal joins: f o r t v w

68

The alphabet joined :

abcdefghijklmnopqrstu

uvwxyz. In Italic handwriting the
 pen is lifted after bg j pqxy
and generally before a cd g q, f & z, but
those rules are often broken to avoid consecutive
pen-lifts: abbey, apple, cadge, asses.

Some letters require two strokes : c, e, f, t, x,
but e may also be done in one stroke, joining
from the bottom - even, seventy

Always use the cross-stroke of t to join on to the
next letter and make the cross-stroke of f go
through the middle of the letter diagonally:

ta, te, ti, to, tu but not th, th

fa, fe, fi, fo, fu but fl.

Double letters : tt (in one movement) ff (the second
 is slightly taller and * stops short *)
 ss (modify the second as illustrated)

atter, attle, offer, offle, osses,
isses, sos (s is modified in three ways!)
 1 2 3

69

Practice material. By far the best practice to enable one to acquire a good Italic hand is the sandwiching of *m* between pairs of each letter of the alphabet: ama, bmb, cmc, dmd, emem (use both forms of e), fmf, gmg, hmh, imi, jmj, kmk, lml, nmn, omo, pmp, qmq, rmr, sms, tmt, umu, vmv, wmw, xmx, ymzm.

Another suggested method is to practise three-letter words, going through the alphabet, as the extent of movement of the hand is limited, generally, to this number of letters: art, bag, cut, din, elm, fun, gap, hoe, ink, jib, key, lid, man, net, oar, peg, quip. ram, six, tea, urn, van, way, zoo

Try writing familiar sayings:

A stitch in time saves nine

Empty barrels make most noise

Speech is silvern, silence is golden.

Formal Italic Handwriting

is distinguished from the Simple model by
the ascenders with their pushed strokes to the left:

b d h k l and a similar addition
to the descender of p : p

abcdefghijklmnopqrstuv
wxyy&z AbCdEfGhIjK

This style has many more pen-lifts than the Simple
Italic, hence it is not suitable for everyday purposes
but rather for those special occasions where a certain
elegance is called for, such as wedding invitations,
engagement & birth announcements or wherever
fine or formal handwriting would be more accept-
able. It is for high days & holidays! One may then
indulge in certain exaggeration of features such as
the elongation of ascenders & descenders & the addition
of finishing flourishes to l : l and x : x.

abcdefghijklmnopqrstuvw
xyz
&
l However do not overdo the
flourishes. A little decoration
goes a long way!

abcdef

George

ghijk

l

mnopqrs

Thomson

uvwxyz

UNCIAL *from "The Complete Calligrapher"*

George Thomson

72

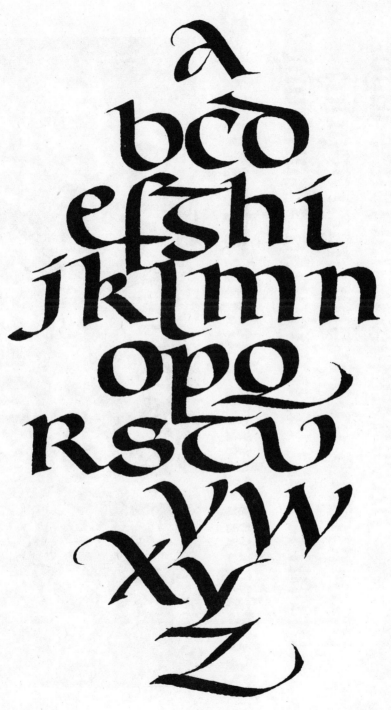

Donald Murray

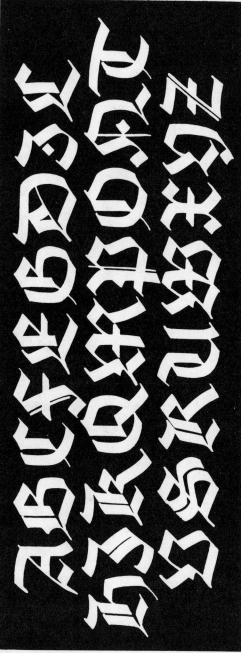

A dam beril cæfar david elbe fauft medok niklas omar jonas fagor pech quintus febald thüringen vogelen urban wodka ferres ylop 3a Hamburg

abcdefghijklmnopqurstuvoxyz

Hildegard Korger

J K L M

A B C D E F G H J

N O P Q R S T U V

Zum Besten
der gesamten
Menschheit
kann niemand
beitragen
der nicht
aus sich selbst
macht,
was aus ihm
werden kann
und soll.

W X J Y Z

Hildegard Korger

75

ABCDEFGHIJK
LMNOPQRST
UV:WXYZ&

BROAD PEN CAPITALS *Done five nib widths high. It is recommended they also be written at five and one half, six, and seven. Pen angle is maintained with very little variation throughout. Freer version of some letters:* AEFGKLMNTIIVWXYZ

James Hayes scripsit, Colorado

James Hayes

Sheila Waters

ABCDEFGHIJKLMN
OPQRSSTUVWXYZ&

ABCDEFGHIJKLMP
QRSTUW
ABCDEFGHIJKLMN
OPQRSTUVWXYZ&
WXYZ · Capitals based on
Weiss · Capitals based on
Italic Caps and finials

Two varieties of
capital to go with
the Johnston-style
of Compressed hand

77

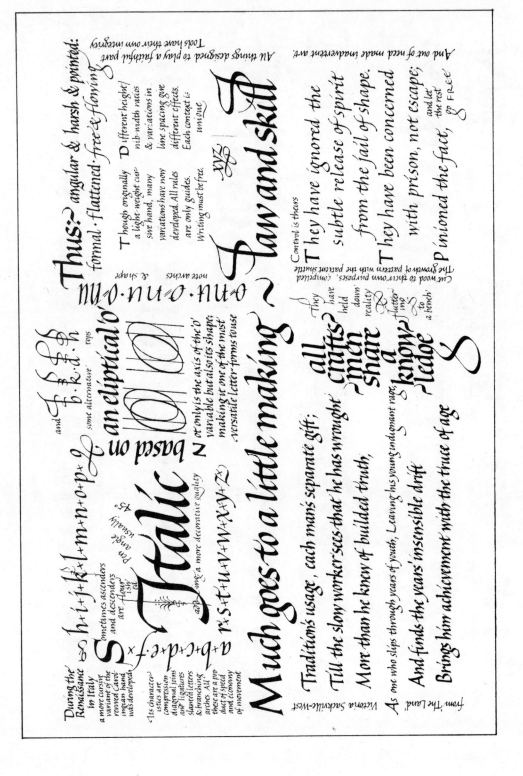

During the Renaissance in Italy a more cursive variant of the rounded Carolingian hand was developed.

Its characteristics are compression diagonal joins and ligatures slanted letters & branching arches All these are a product of speed and economy of movement

Sometimes ascenders and descenders are fewer

some alternative tops

Italic

based on an elliptical 'o'

Pen angle usually 45°

Bring a more decorative quality

Not only is the axis of the 'o' variable but also its shape; making it one of the most versatile letter-forms to use

note arches & shape

Thus? angular & harsh & pointed: formal · flattened · free & flowing

Though originally a light-weight cursive hand, many variations have now developed. All rules are only guides. Writing must be free.

Different height/ nib-width ratios & variations in line-spacing give different effects. Each context is unique.

All things designed to play a faithful part / Tools have their own integrity

And out of need made inadvertent art.

law and skill

Much goes to a little making

Tradition's usage, each man's separate gift;
Till the slow worker sees that he has wrought
More than he knew of builded truth,
As one who slips through years of youth, Leaving his young indignant race,
And finds the years' insensible drift
Brings him achievement with the truce of age

from The Land · Victoria Sackville-West

Control is theirs

They have ignored the subtle release of spirit from the jail of shape.

They have been concerned with prison, not escape;

Pinioned the fact, and let the rest go free

The growth of pattern with the pattern shuttle
...wood to their own purposes, compelled

all crafts men share a know-ledge

They have held down reality to flatter me to a bench

Julian Waters

THE FOUNDATIONAL HAND:

Bookhand from 10th cent. English manuscript writing

abcdefghijklm

FORMATION OF SERIFS: 'Rolled Serifs'

— are made in the course of the main downstroke.

nopqrstuvwxyz

45°

30°

'Beaked serifs are formed thus: 'Slab' serifs:

1 nib widths or 3X body height

30°

ABCDEFGHIJKL
MNOPQRSTUV
WXYZ

Capitals with simple serifs Pen angle same as above.

Use these with the Foundational Hand

Julian Waters 1975

79

GELUID
ZO GOED IS
GOD
HIJ GAF DE WINDEN

bomen om te waaien,
de stromen oevers
voor hun lied
maar aan de dichter
gaf hij woorden
anders niet

LEO BOEKRAAD

Tom Gourdie

80

Through this frail glass have eyes a few
Seen on the gruss a fairy dew
Or afternoon with work well done—
A pumpkin moon pretend the sun.

When I too pass, to those who come—
Here where I was may it be home
Under skies clear or blue-black even
Let them keep dear this porch to Heaven.

How beautiful
upon the mountains
are the feet of him that bringeth
good tidings that publisheth peace;
that bringeth good tidings of good,
that publisheth salvation; that saith
unto Zion, Thy God reigneth!

ISAIAH 52-7

James
Hayes

* James Hayes scripsit, Woodland Park, Colorado, 10-14-74 *

Oregon Implant Research SEMINAR

Certifies that

being duly qualified & having fulfilled all requirements is hereby elected a member of this society.

In witness whereof this certificate has been signed & presented this day of

SECRETARY

PRESIDENT

Robert Palladino

The Rev. Bernard Deegan

OMNES
ARTES

QUAE AD HUMANI=
All arts which have

TATEM PERTINENT HABENT
anything to do with man

QUODDAM COMMUNE VIN=
have a common bond

CULUM ET QUASI COGNATI=
and, as it were, contain within themselves

ONE QUADAM INTER SE
a certain affinity

CONTINENTUR

MARCUS TULLIUS CICERO

OUR
DEBT
IS
LARGELY
TO
EDWARD
JOHN-
STON

ALSO
TO
W.R.
LETHABY

WHO
HAD
THE
PER-
CEPTION
TO
SENSE
JOHN-
STON'S
LATENT
GENIUS

¶ WITHIN THE
LIMITS OF
OUR CRAFT
WE CANNOT
HAVE TOO MUCH
FREEDOM

Irene Wellington

84

The Trustees
of the
Boston Public Library
cordially invite you to
the opening of an exhibition
in honor of the
Fiftieth Anniversary of
The Horn Book Magazine
on
Monday evening, October 7, 1974
at eight o'clock
Boston Public Library
Copley Square

ϰ

Reception at 9:00 p.m. · The Boston Room

Edward A. Karr

85

On Tuesday evening, March the First

The New York City Ballet

is appearing at the Kennedy Center

We hope you can join us for the performance

and a buffet supper afterward in the

South Opera Lounge

R.S.V.P.
and ticket reservations
before February 22nd
Mrs. Boggs. 337·1855

Warmest regards
John S. Samuels, 3d
Chairman: N.Y. City Ballet
& Mrs. Phyllis D. Collins

Sheila Waters

Frank McGrath

By the Governor of Northern Ireland

WHEREAS by Section 1 of the Parliamentary Commissioner Act (Northern Ireland) 1969 the Governor of Northern Ireland may appoint the Northern Ireland Parliamentary Commissioner for Administration:

NOW THEREFORE I RALPH FRANCIS ALNWICK BARON GREY OF NAUNTON Knight Grand Cross of the Most Distinguished Order of Saint Michael and Saint George Knight Commander of the Royal Victorian order officer of the Most Excellent Order of the British Empire Governor of Northern Ireland do hereby pursuant to the powers vested in me by the said Act in that behalf appoint JOHN MERITON BENN Esquire Companion of the Most Honourable Order of the Bath to be the NORTHERN IRELAND PARLIAMENTARY COMMISSIONER FOR ADMINISTRATION with effect from 1 January 1972 to have and to hold the said office during good behaviour with all the powers and duties belonging thereto and in accordance with and subject to the provisions of the Parliamentary Commissioner Act (Northern Ireland) 1969 and all other Statutes in this behalf made and provided.

MINISTER OF COMMUNITY RELATIONS
FOR
NORTHERN IRELAND

Given at Government House, Hillsborough
this 15th day of December 1971

BY HIS EXCELLENCY'S COMMAND

How justly bold when in some Master's hand
the pen at once joins freedom with command
With softness strong, with ornaments not vain
Loose with proportion, and with neatness plain
Not swelled, yet full, complete in every part
And artful most when not affecting art.

CONGRESSMAN
MICHAEL J. HARRINGTON

Colleen

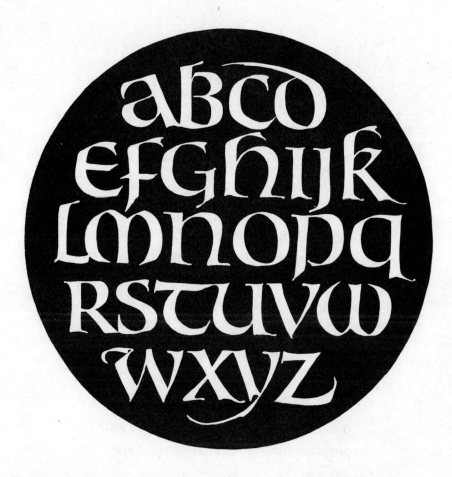

ABCD
EFGHIJK
LMNOPQ
RSTUVW
WXYZ

VALEAS
qui legis,
quod scripsi

Philip Bouwsma

89

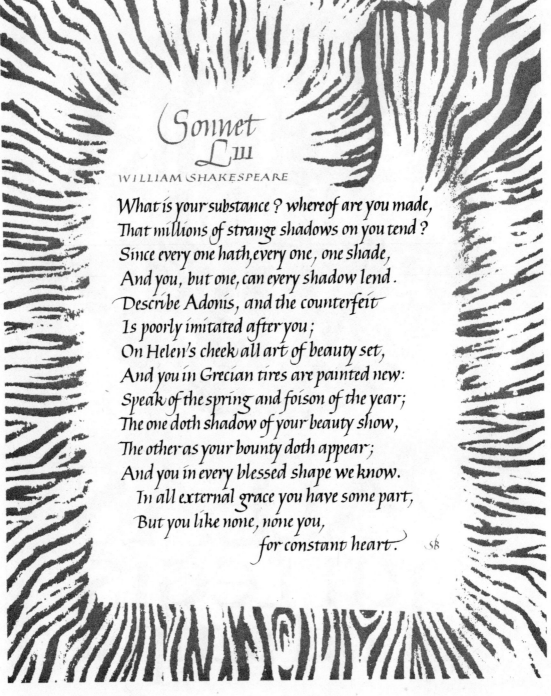

Sonnet LIII

WILLIAM SHAKESPEARE

What is your substance? whereof are you made,
That millions of strange shadows on you tend?
Since every one hath, every one, one shade,
And you, but one, can every shadow lend.
Describe Adonis, and the counterfeit
Is poorly imitated after you;
On Helen's cheek all art of beauty set,
And you in Grecian tires are painted new:
Speak of the spring and foison of the year;
The one doth shadow of your beauty show,
The other as your bounty doth appear;
And you in every blessed shape we know.
 In all external grace you have some part,
 But you like none, none you,
 for constant heart.

Stuart Barrie

SPLENDIDIS LONGUM VALEDICO NUGIS

Leave me, O Love, which reachest but to dust,
 And thou, my mind, aspire to higher things!
Grow rich in that which never taketh rust:
 Whatever fades, but fading pleasure brings.
(Draw in thy beams, and humble all thy might
 To that sweet yoke where lasting freedoms be;
Which breaks the clouds and opens forth the light
 That doth both shine and give us sight to see.
O take fast hold! let that light be thy guide
 In this small course which birth draws out to death,
And think how evil becometh him to slide
 Who seeketh Heaven, and comes of heavenly birth.
Then farewell, world! thy uttermost I see:
 Eternal Love, maintain thy life in me.

SIR PHILIP SIDNEY

Written for Richard Harrison by Jeanyee Wong 1958

Jeanyee Wong

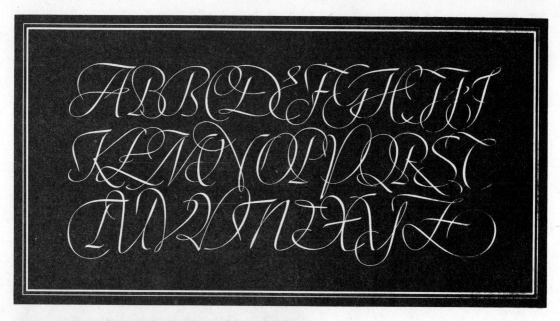

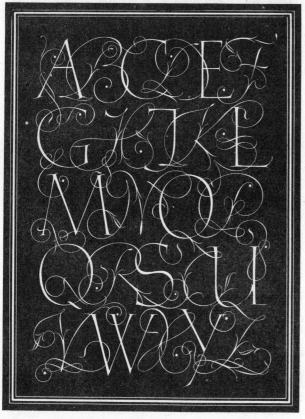

Alphabets
by
Hermann
Zapf

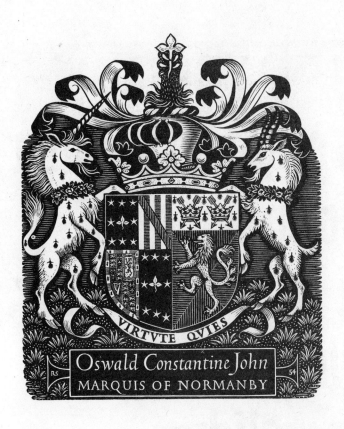

Oswald Constantine John
MARQUIS OF NORMANBY

Reynolds Stone

DIThyRAMbe

Alles geben die Götter,
die unendlichen,
ihren Lieblingen ganz,
alle Freuden,
die unendlichen,
alle Schmerzen,
die unendlichen, ganz.

J. W. goethe

Eugen Kuhn

94

1 A fredome is A noble thing
2 fredome mayß man to haiff liking
3 fredome all solace to man giffis
4 he levys at eß ÿ frely levys
5 A noble hart may haiff nane eß
6 Na ellys nocht ÿ may him pleß
7 Gyff fredome failyhe for fre liking
8 Is ÿharnyt our all othir thing
9 Na he ÿ ay haß levyt fre
10 May nocht knaw weill ye propyrte
11 Ye angyr na ye wrechyt dome
12 That is couplyt to foule thyrldome.

1 Ah! freedom is a noble thing.
2 Freedom makes [possible] man to have choices.
3 Freedom all solace to man gives.
4 He lives at ease that freely lives.
5 A noble heart may have nothing else
6 Nay, naught else that may him please
7 If freedom fails; for free choosing
8 Is yearned for over all other things.
9 He that always has lived free
10 May not know well the properties,
11 The anger, nor the wretched doom
12 That is coupled to foul thralldom.

Graphic Arts · Reed College · 1967

Lloyd Reynolds

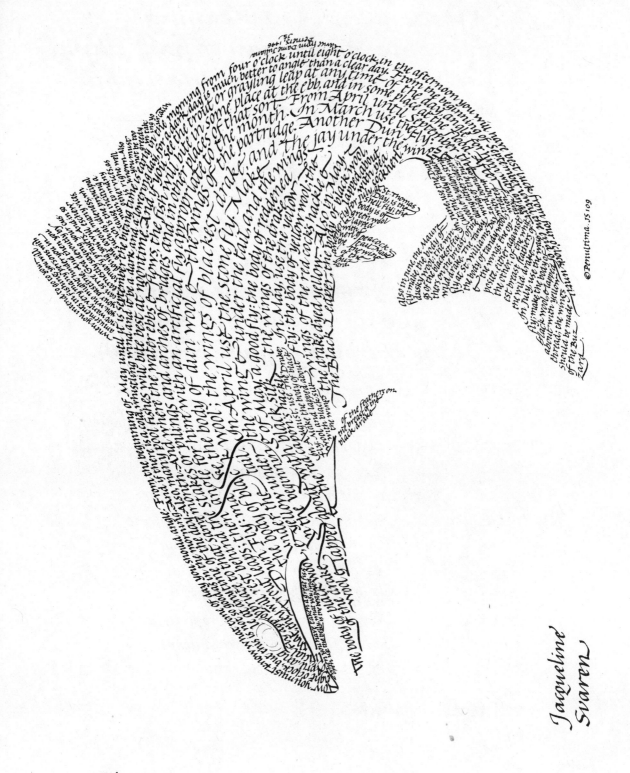

Jacqueline Svaren

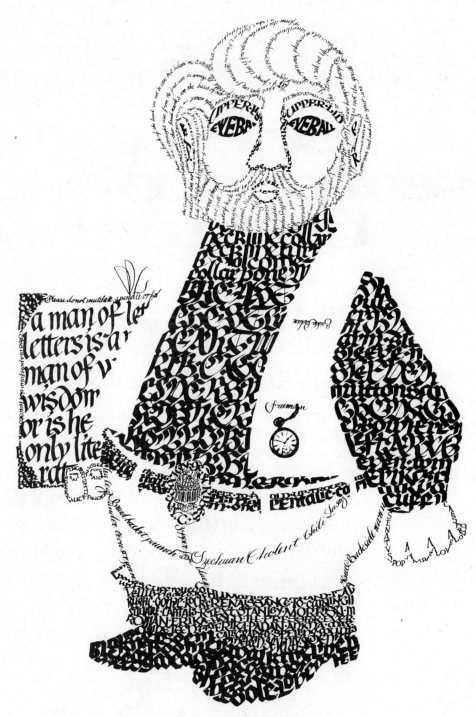

A self-portrait Paul Freeman

97

Eisteddfod ~ Ceilidh proudly presents
an evening of traditional Irish music

joe heaney
seamus connolly
de danann

Friday ~ October 21st '77 ~ Eight pm
Southeastern Massachusetts University
Auditorium ~ Tickets sold at the door
$3.00 ~ SMU students & faculty $2.00

ceilidh calendar
informal gatherings for music making
north lounge group one bldg. 8:00 pm

November 4th February 24th
December 2nd March 31st
January 27th April 28th

Howard Glasser

98

Today Christ is born

Hodie Christus natus est

Today the Savior has appeared

Hodie Salvator apparuit

Today on earth Angels sing

Hodie in terra canunt Angeli.

Archangels rejoice

laetantur Archangeli

Today the righteous exult, saying

Hodie exultant justi, dicentes

Glory to God in the highest

GLORIA 'N EXCELSIS
DEO

May the joys of this holiday season
be with you on His birthday
and through the new year.
Christmas
1974

Roy, Hazle, Georgina & Tom Rice

Roy Rice

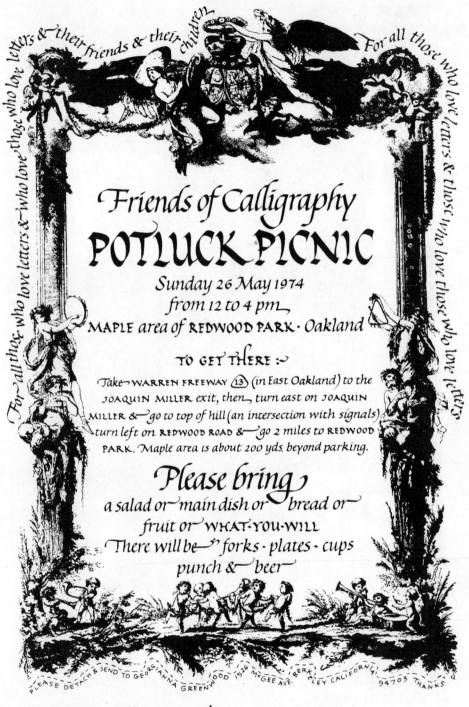

For all those who love letters & those who love those who love letters · For all those who love letters & who love those who love letters & their friends & their children

Friends of Calligraphy
POTLUCK PICNIC
Sunday 26 May 1974
from 12 to 4 pm
MAPLE area of REDWOOD PARK · Oakland

TO GET THERE :~

Take WARREN FREEWAY (13) (in East Oakland) to the
JOAQUIN MILLER exit, then, turn east on JOAQUIN
MILLER & go to top of hill (an intersection with signals)
turn left on REDWOOD ROAD & go 2 miles to REDWOOD
PARK. Maple area is about 200 yds. beyond parking.

Please bring
a salad or main dish or bread or
fruit or WHAT·YOU·WILL
There will be forks · plates · cups
punch & beer

PLEASE DETACH & SEND TO GEORGIANNA GREENWOOD 1526 MEGEE AVE. BERKELEY CALIFORNIA 94703 THANKS

Georgianna Greenwood

TO SEE, YOU HAVE ONLY TO LOOK. IF YOU WANT TO SEE WELL YOU SHOULD LEARN HOW TO DRAW BECAUSE IT MAKES YOU LOOK AT SOMETHING WITH GREAT CARE AND INTENSITY. IT'S BEST TO FORGET ABOUT YOUR LIMITATIONS, PRE-CONCEPTIONS AND ART TRAINING. IT'S A STRICTLY PERSONAL TASK. YOU'RE BOTH TEACHER AND STUDENT.

YOU'LL NEED AN ASSORTMENT OF BRUSH HANDLES, PEN HOLDERS, TWIGS, CHOPSTICKS, BLACK INK AND SOME PAPER-ABOUT 9x12.

CHOOSE AND STUDY SOMETHING, WHICH YOU FIND BEAUTIFUL. SELECT A SMALL AREA OR DETAIL. GRASP ONE OF THE BRUSHES VERY LOOSELY AT THE HAIR END AND DIP THE OTHER END IN INK. KEEP LOOKING AT WHAT YOU'RE LOOKING AT AND DRAW **THE SHAPES** YOU SEE. MAKE THEM LARGE ENOUGH TO FILL THE PAPER. WORK SLOWLY, CAREFULLY.

THINK OF WHAT YOU ARE DOING AS A RESPONSE, NOT A SO-CALLED COPY. IF YOU ARE RIGHT-HANDED, TRY USING YOUR LEFT HAND. AFTER YOUR FIRST FIVE-HUNDRED DRAWINGS YOU'LL BE WELL ON YOUR WAY TO SEEING ALL SHAPES (INCLUDING LETTER SHAPES) WITH GREATER SENSITIVITY.

...THE SECRET IS TO HAVE TENDERNESS.
UGO BETTI

DAVID MEKELBURG · DECEMBER 1976

A free essay by David Mekelburg

MY LUV IS LIKE A RED, RED ROSE

O, my luve's like a red, red rose
 That's newly sprung in June:
 O, my luve's like the melodie
 That's sweetly played in tune.

As fair art thou, my bonnie lass,
 So deep in luve am I:
 And I will luve thee still
 Till a' the seas gang dry.

Till a' the seas gang dry, my dear,
 And the rocks melt wi' the sun:
 And I will luve thee still, my dear,
 While the sands o' life shall run.

And fare thee well, my only luve
 And fare thee well a while!
 And I will come again, my luve,
 Though it were ten thousand mile.

Tom Gourdie, Scripsit Robert Burns

WHOEVER·HAS
HAS·MADE
LETTER
SLAVE
TAUGHT
ME
HIS
ONE·ME·ONE·
ME·ONE
HT

David Kindersley

a tot z het allerbeste voor het jaar 1960

abcdefghijklmn
opqrstuvwxyz

Wij wensen U van

Chris en Denise

Brand · de Werstraat 9 A · Breda

Chris Brand

NATIONAL LIBRARY OF SCOTLAND

GEORGE IV BRIDGE EDINBURGH

EXHIBITION

International Calligraphy and Lettering

Three Lectures

on Calligraphy and Lettering

will be given as below

Thursday 25th August 1960 at 8pm. Tom Gourdie, Esq., M.B.E., author & calligrapher

Thursday 1st September 1960 at 8pm. Stuart Barrie, Esq., Edinburgh College of Art

Thursday 8th September 1960 at 8pm. William Park, Esq., Keeper of Manuscripts

ADMISSION FREE

Stuart Barrie

No. 25. Pointed Italic Capitals

ABCDE
FFGHIJK
LMNOP
QRSTUV
WXYZ

25

No. 22 Chancery cursive.

Note similarities in construction:

A ABCDEFG
HIJKLMNO
PQRSTUVW
XYZ abcdefghijkl
mnopqrstuvwxyyz & nnn
Ludovico degli Arrighi, Giovan=
antonio Tagliente, Giovanni
Francesco Cresci, Pierantonio
Sallando, Girolamo Pagliarolo
22

105

Index